VANISHING POINT

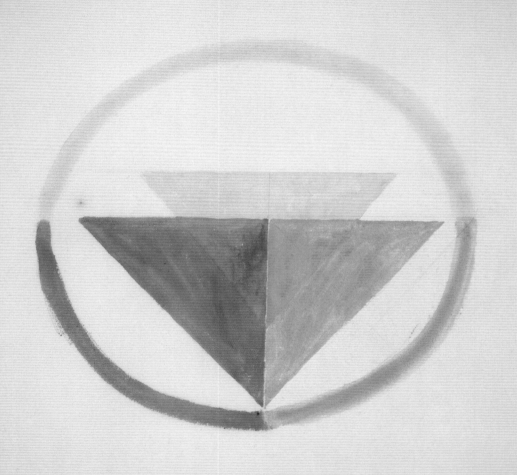

No 1

# VANISHING POINT

## THE PERSPECTIVE DRAWINGS
## OF J.M.W. TURNER

### ANDREA FREDERICKSEN

TATE PUBLISHING

First published 2004 by order of the Tate Trustees
by Tate Publishing, a division of Tate Enterprises Ltd,
Millbank, London SW1P 4RG
www.tate.org.uk/publishing

*British Library Cataloguing in Publication Data*
A catalogue record for this book is available
from the British Library

ISBN 1-85437-568-7

Distributed in the United States and Canada by
Harry N. Abrams, Inc., New York

*Library of Congress Cataloging in Publication Data*
Library of Congress Control Number 2004102507

Designed by Caroline Johnston
Printed in Hong Kong by South Sea International Press

*Front cover*: J.M.W. Turner, *Lecture Diagram 11: Spheres at
Different Distances from the Eye*, c.1810 (plate 5)

*Frontispiece*: J.M.W. Turner, *Colour Circle No.1*, c.1824–8,
pencil and watercolour on paper,
556 × 762 mm (D17149 / TB CXCV 178)

# VANISHING POINT:
# THE PERSPECTIVE DRAWINGS OF J.M.W. TURNER

As Professor of Perspective at the Royal Academy, a post to which he was elected in 1807 and held until 1837, J.M.W. Turner (figure 1) sought to open his students' minds to the theory and practice of this discipline. When he stepped up to the podium one evening in 1814, however, and looked out over a fresh round of students who had been waiting for over an hour to hear him speak, Turner was forced to apologize for his negligence as a teacher. He had left his portfolio containing both his diagrams and notes behind in the Hackney Cab and would be unable to deliver the first of his lectures.[1] Luckily Henry Fuseli, the Academy's Professor of Painting, agreed to step in and deliver his own lecture instead, saving Turner from an 'embarrassing situation' for which he offered his 'most unfeigned thanks' when he gave his delayed class the next week.[2] By then he had recovered his lost lecture material, after putting a notice in the *Morning Chronicle* offering a 'two pound reward, if brought before Thursday, afterwards only one pound will be given for them at the end of the week. No greater reward will be offered nor will this be advertised again.'[3]

His resourcefulness did little to save him from his critics. Turner was already notorious for his unorganized lectures, which were often repetitious and difficult to follow, but also his tendency to lose his place and mumble under his breath. One reviewer from the *New Monthly Magazine* found the 'vulgarity of his pronunciation' particularly embarrassing, for he was apt as a Londoner to pronounce mathematics as 'mithematics', spheroids as 'sphearides' and to say 'haiving' or 'towaards'.[4] Clearly a poor public speaker, the professor struggled to convey the import of his subject. He found greater success with the perspective drawings he created to illustrate the lecture material. These, one student explained, 'were truly beautiful, speaking intelligibly to the eye if his language did not to the ear'.[5] John Ruskin, himself the author of a perspective treatise, praised the 'wonderful series of diagrams' as 'exquisitely tinted, and often completely coloured, all by his own hand, of the most difficult perspective subjects; illustrating not only directions of line, but effects of light, with a care and completion which would put the work of an ordinary teacher to utter shame'.[6]

Turner produced about 180 known perspective drawings. He made about half of these when preparing the lectures in around 1810, but continued to add more up until the last decade of his tenure as professor. Most are mathematical diagrams (plate 1) based upon the sources he consulted, with many taken from books by John Joshua Kirby (1716–74) and Thomas Malton (1726–1801). His technique was quite free; most drawings are rendered without straight edges in bold strokes of red and black watercolour over indications of pencil. He then scrawled in large letters the name of his source or the terminology illustrated above or below the diagram. Also included are a number of beautifully rendered watercolours of mostly architectural subjects demonstrating applied perspective (plate 2). For these Turner adopted a more complex transfer process.[7] He placed a sheet of paper coated with black ink under his preparatory drawing and then traced over the outlines to generate a copy, sometimes multiple copies. Once he had his guiding lines he then finished the drawing with watercolour. The perspective drawings from the early years of preparation have large red numbers at the top left corner which correspond to a numbering system found in the lecture texts.[8] Although he took great pains to prepare the diagrams, he seems to have been concerned neither with the quality of paper he used nor with his care of the final drawings, since many sheets show signs of early deterioration and some have his cats' paw prints tracked across them in various muddy shades of watercolour.[9]

Turner's lecture drawings are now housed in the Turner Bequest at Tate Britain. Along with all other works that were part of his studio at his death in 1851, they were given by the terms of his will to the British nation 'for the benefit of the Public'.[10] The corresponding lecture manuscripts are located at the British Library.[11] This archival collection consists of lectures in various stages, draft and transcription, most of which are undated except by watermark. Because Turner made frequent revisions to the texts, so that each is riddled with often indecipherable amendments and alterations, it is difficult to put the lecture material into coherent order. To this day only one lecture has been fully published, and the subject remains largely unstudied.[12] As a result, the accompanying diagrams – the material that grabbed his audience's attention for its beauty and completion – continue to be an intriguing and elusive aspect of the artist's career.[13]

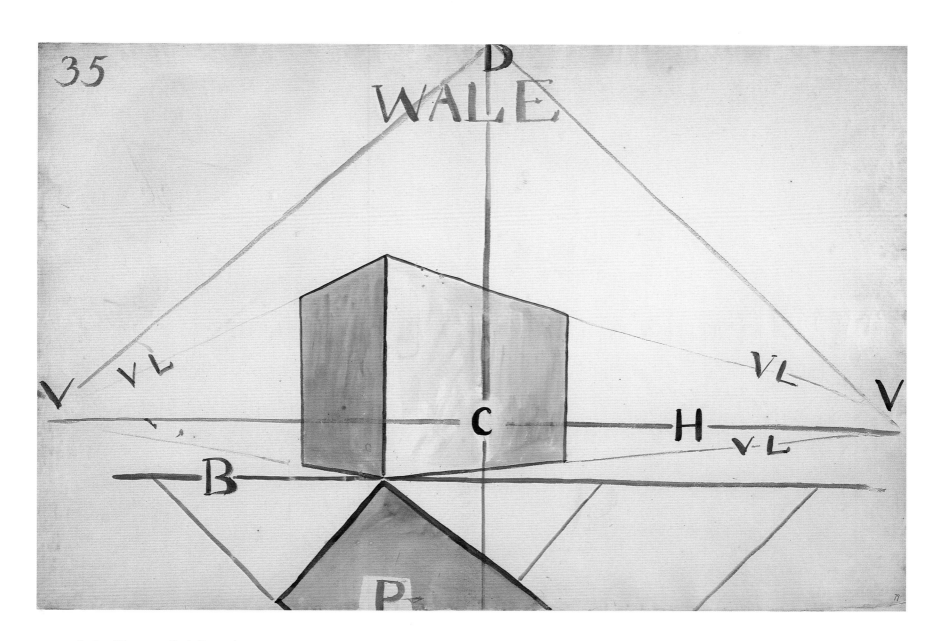

PLATE 1 *Lecture Diagram 35: Basic Perspective Method for a Rectangular Object, c.1810*
pencil and watercolour on paper, 672 × 998 mm
(D17049 / TB CXCV 79)

## THE ROYAL ACADEMY LECTURES

Created in 1768, the post of Professor of Perspective carried with it the obligation to 'read annually six public lectures in the Royal Academy, in which the most useful propositions of geometry, together with the principles of linear and aerial perspective, shall be fully and clearly illustrated'.[14] The position had been held first by the draughtsman and book illustrator Samuel Wale (c.1721–86) and then by the painter Edward Edwards (1738–1806). When no obvious candidate for the position came forward after Edwards's death, Turner offered his services in the hope of being useful to an institution to which he felt he owed everything.[15] As the son of a barber, and since 1802 a respected, full member of the Academy, he may have been drawn to the idea of holding an academic post because of the prestige.[16] Whatever his motivation, the Royal Academy, with the venerable Benjamin West as its president, must have been delighted to have him as a member of their teaching staff. Here he would join an influential cast of academics, including the aforementioned Henry Fuseli (1799–1805; 1810–25), John Soane, the newly appointed Professor of Architecture (1806–37), John Flaxman, soon to be the Academy's first Professor of Sculpture (1810–26), and Anthony Carlisle, the popular and charismatic Professor of Anatomy (1808–24).[17] He, like the others, would receive £60 for each annual course of six lectures.

Once elected to his professorship on 10 December 1807 he took over two years to prepare his material. Whenever he could tear himself away from his painting, he studied a wide range of books on the theory and practice of perspective and extracted from them the procedures and illustrations he found useful.[18] Over time he filled sheets of paper and sketchbooks with diagrams and notes and then organized them into his six-part lecture course.[19] He then had them written out by a professional scribe named William Rolls. He began the series with an introduction to the benefits of learning perspective. This was followed by a lecture outlining the basic definitions and theorems of perspective and then two concerned with its application. He also prepared a lecture on 'aerial' or atmospheric perspective, and then concluded the course with a general talk on the role of architectural and landscape backgrounds in Old Master paintings. Once the lectures were ready for use, Turner could not refrain from making immediate changes and would often return to the texts over the years in order to improve them. But because his research methods were at times haphazard and even sloppy, so that he might base his entire understanding of a procedure upon a diagram alone rather than consulting his source's accompanying descriptive text, the results were often inadequate or

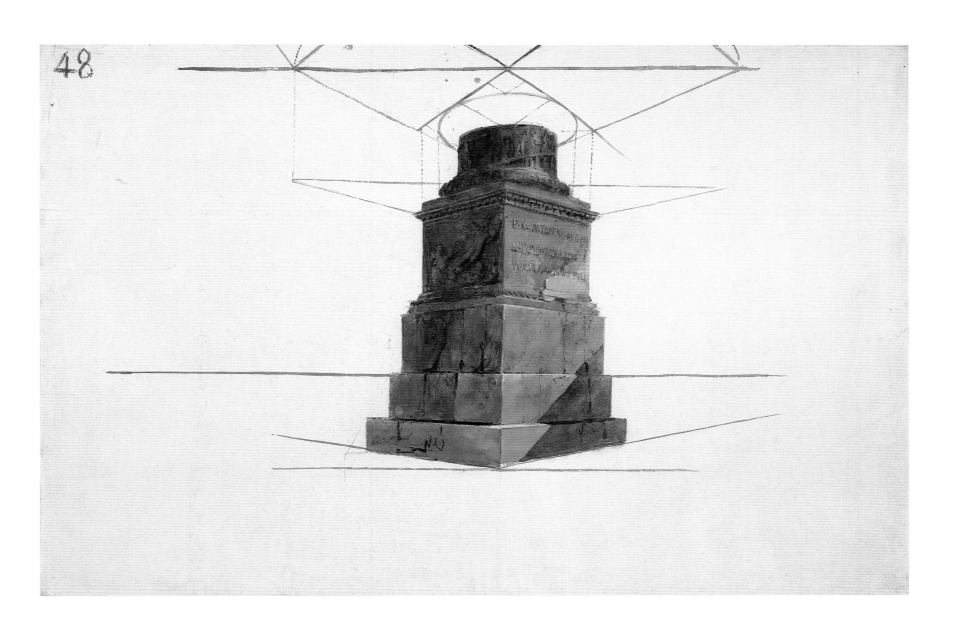

PLATE 2 *Lecture Diagram 48: Pedestal of the Column of
Antoninus Pius, c.*1810
pencil and watecolour over transfer ink on paper, 642 × 982 mm
(D17065 / TB CXCV 95)

inaccurate.[20] At other times, however, he reveals an insight into the material – particularly when it concerned such favorite topics as colour – that marks a true advance in the field.[21]

Turner gave his lectures in the Great Room at Somerset House, the home of the Royal Academy from 1780 to 1836 (figure 2). Talks were attended by students of both the Antique and Life Model schools, which included painters, architects and sculptors. Though attendance was not compulsory, students could only be eligible for the gold medal Premium if they had been regular visitors to the various courses on offer.[22] Academicians also came to the lectures, as did a few male members of the general public, who had to apply for tickets for admittance. A sketch by John Linnell records William Turner, the artist's father, who was known to attend with faithful regularity (plate 3). The conditions offered by the hall were far from ideal, as it had been designed by Sir William Chambers for the display of pictures during the annual exhibition and not for lectures held on dark winter evenings. For the lecture season, which ran from October to March, rows of seating were brought in and the walls were hung with works from the Academy's permanent collection. This arrangement proved useful for Turner, since he often referred his students to Sir James Thornhill's reproductions of Raphael's Cartoons hanging above their heads. Yet he had to rely on oil lamps to illumine his examples because the Diocletian windows which normally flooded the room with natural lighting from above during the day did little in the evening. In 1809, even before he began lecturing, Turner offered proposals for improving the lighting in the room, while John Soane made recommendations for seating.[23] In 1812 the Prince Regent gave the Academy an enormous bronze lamp with thirty lights on individual branches, which hung suspended by a chain from the ceiling.[24]

Turner may have had trouble projecting his voice across the Great Room, but he made his diagrams big enough, often as large as 2 feet by 3 feet, so that they would be visible from the back row. We know that assistants took the diagrams on and off the stage as he lectured; the lack of pin marks indicates that it is most likely that they were placed on stands. According to one report, 'half of each lecture was addressed to the attendant behind him, who was constantly busied, under his muttered directions, in selecting from a huge portfolio drawings and diagrams to illustrate his teaching.'[25] At one point someone complained that the diagrams were put off and on too quickly. This may have given him the idea to leave them all up during the entire lecture, until another annoyed audience member argued that it was not clear to which diagram he was referring.[26] He continually added new diagrams to supplement his material, but also brought in plaster casts, prints and his own watercolours, and even used the architecture of the lecture hall to illustrate his points.

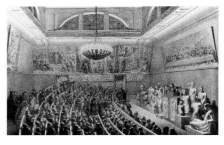

FIGURE 2 George Sharf 1, *Westmacott's Lecture on Sculpture at the Royal Academy, Somerset House*, c.1830
lithograph on paper, 265 × 355 mm
Guildhall Library, Corporation of London

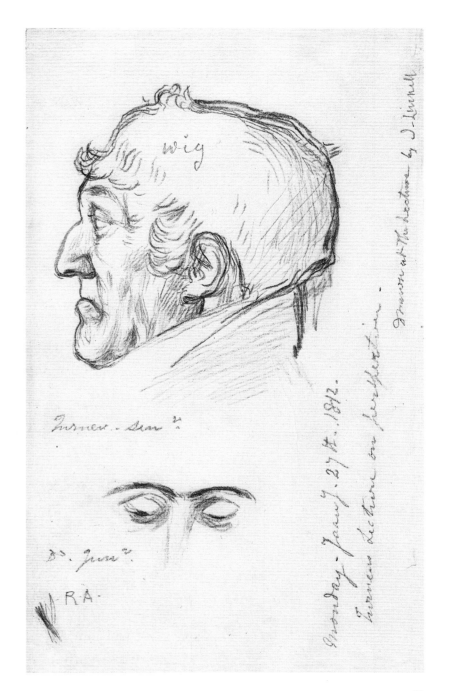

PLATE 3 John Linnell, *Portrait Study of J.M.W. Turner's Father, with a Sketch of Turner's Eyes, Made during a Lecture*, 1812
pencil on paper, 187 × 225 mm
(T03117)

## THE DIAGRAMS

A brief survey of his perspective drawings, particularly as they relate to the lectures, reveals that Turner intended his diagrams to illustrate both the theory and practice of standard perspective, often with the aim of revealing its failings. In his introduction to the theorems and terms of perspective, which formed the core of Lecture 2, for instance, he referred to a model used since the Renaissance to demonstrate that a perspective representation is an intersection of the cone of vision (plate 4). But he was largely unimpressed with the importance placed upon this basic model, explaining that 'its simplicity is its only beauty, and when divested of the intricacies with which it has been clothed is nothing more than a plane between the eye and the object on which that object is supposed or appears to the eye'.[27] Yet he clearly felt it important that they understand the rules substantiating the model, since he proceeded to describe the basic principles of perspective theory. Here Turner relied upon Thomas Malton's *A Compleat Treatise on Perspective, in Theory and Practice* (1775) for many of his ideas and illustrations. Diagram 11 (plate 5), for example, provides a model of vision as a cone of rays travelling from various globes towards the eye in order to illustrate Malton's first theorem that 'Objects appear to have that Proportion to each other, respectively, as the angle under which they are seen.'[28] Turner explained that if the diameters of globes are in proportion to their distances they seem equal to the eye. He demonstrated this by showing equal-sized globes on the retina on the right, but he also expanded upon Malton to explore what the model suggests in regard to the discrepancies between vision and perspective.[29]

Continuing with his study of perspective theory in Lecture 2, he made sure also to include diagrams illustrating basic terminology. Lecture Diagram 15 (plate 6), for instance, shows those introduced by Dr Brook Taylor (1685–1731), a British mathematician who coined the term 'vanishing point'. Turner used the diagram to exemplify such common terms as horizontal plane, centre point, point of sight, and base line, though he felt these were probably so well known by his students that he promised to be 'as brief as the terms themselves will allow me'.[30] He also included diagrams showing expressions employed by lesser known writers, such the English hydrographer and mathematician Joseph Moxon (1627–1700), who wrote a manual with pop-up illustrations entitled *Practical Perspective, or Perspective Made Easie* (c.1670). Turner presented some of these diagrams again elsewhere in the lectures, finding that they proved useful as reference when describing more complicated procedures. A diagram (plate 7) illustrating terms he ascribed to Thomas Malton Junior (1748–1804), for instance, was used in

PLATE 4  *Geometry of Standard Perspective as the*
*Intersection of the Cone of Vision, c.1816–28*
pencil and watercolour on paper, 482 × 602 mm
(D16971 / TB CXCV 2)

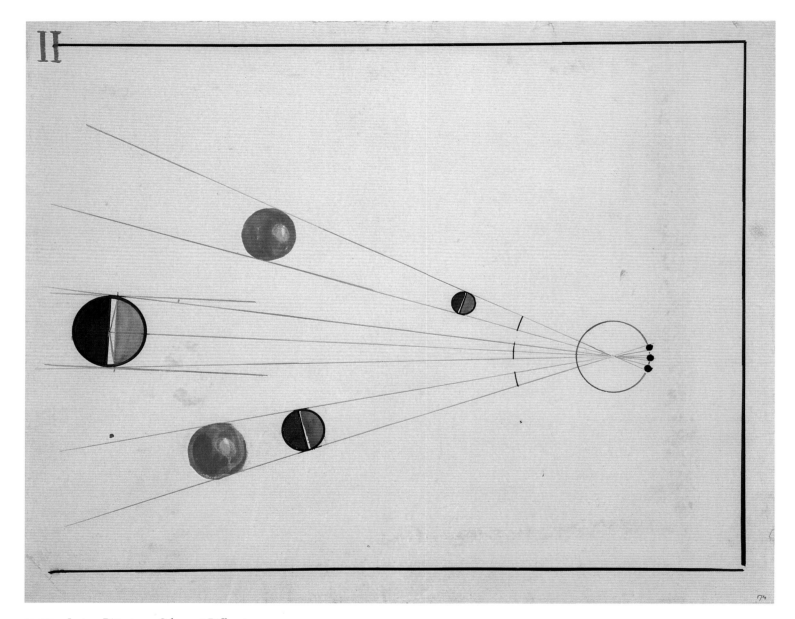

PLATE 5  *Lecture Diagram 11: Spheres at Different*
*Distances from the Eye, c.1810*
pen and ink, watercolour on paper, 485 × 602 mm
(D17145 / TB CXCV 174)

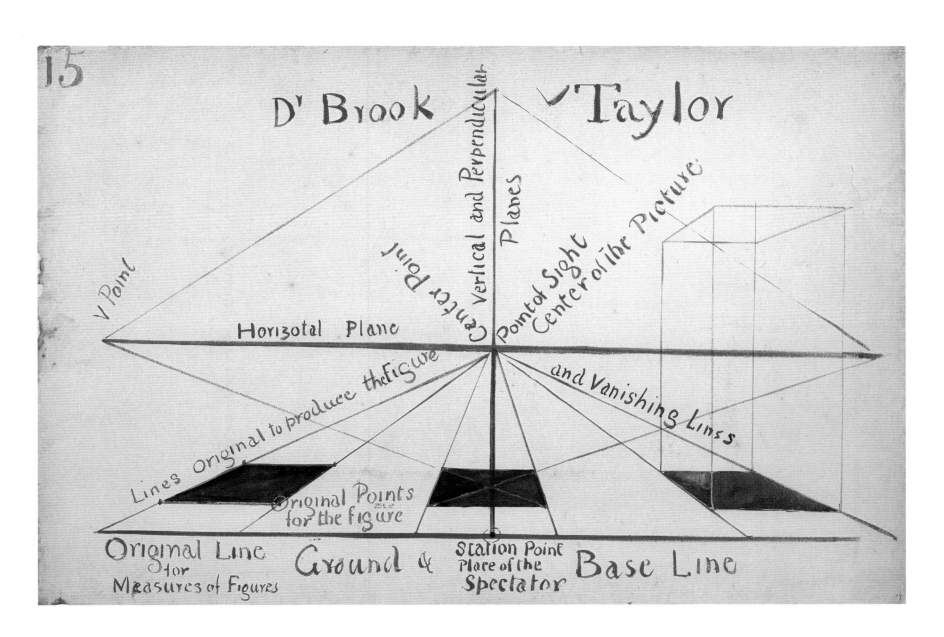

PLATE 6  *Lecture Diagram 15: The Terminology of*
*Dr Brook Taylor, c.*1810
watercolour on paper, 677 × 1015 mm
(D17029 / TB CXCV 59)

sections on terminology and the practical application of the 'measure point' method, a technique he found particularly useful for drawing buildings in perspective.[31] He may have also relied upon this particular diagram because Malton Junior would have introduced him to many of these basic principles when Turner joined his studio as an apprentice draughtsman in the late 1780s.[32]

Throughout Lecture 2, and indeed throughout the entire course, Turner intended his diagrams to reveal the relative simplicity of these ideas. Diagram 18 (plate 8), for instance, demonstrates various principles of rectilinear perspective, the branch of standard, or linear, perspective dealing solely with straight lines, that may at first sight 'appear rather intricate' but with perseverance are actually 'analyzable'.[33] Nevertheless he seems perversely drawn to the more problematic aspects of his subject. Without adequately analysing the rectilinear, for example, he launches into a lengthy discussion of curvilinear perspective, its use in depicting curved forms and lines, and the problems one may encounter.[34] For this section he produced a series of diagrams based on illustrations from Malton Senior that illustrate various conic sections (the conic section being the curve that is formed by the intersection of a plane and a cone). He used these drawings to discuss the representation of such curved forms as the circle, ellipse, parabola and hyperbola (plates 9–11). Turner had little confidence in the ability of perspective to treat the curvilinear, and concluded Lecture 2 with a lengthy discussion of the ways in which distortion occurs.

While Turner freely admitted, if not relished, the fact that perspective has its limitations when coping with curved objects, he maintained that such contradictions 'should impel us onwards not by prejudice for or against any one system', but to know 'how far they are valuable'.[35] It was important therefore that his next two lectures on applied perspective should convey this point and he spent a large portion of Lecture 3 providing a history of simple techniques for drawing a square or cube in parallel perspective. He chose parallel perspective, a method used to depict rectilinear objects parallel to the picture plane, because it was relatively simple to apply. Here he covered a wide range of material, beginning with a method proposed by Jean Pélerin (c.1435–1524), a French cleric and architect who took the name 'Viator' and wrote the first treatise on perspective to be published in Europe. He also included examples from Jacques Androuet Du Cerceau (1515–85) (plate 12), Andrea Pozzo (1642–1709) and Hans Vredemans de Vries (1527–1606) (plate 13), a Dutch designer, architect and painter whose *Perspective* (1604) provided many highly inventive illustrations of mostly architectural scenes and had a far-reaching impact upon northern European artists.[36] He also demonstrated a method proposed by Jacopo Vignola (1507–73) (plate 14), an Italian painter and architect, most famous for his

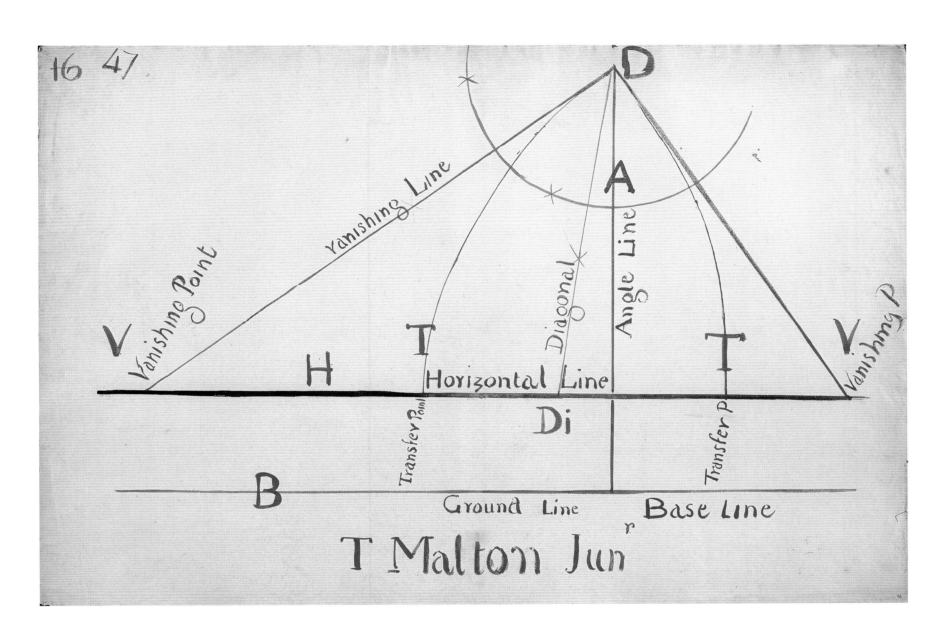

PLATE 7 *Lecture Diagram 16, Later Renumbered 47:*
*The Terminology of Thomas Malton Junior, c.1810*
watercolour on paper, 675 × 1002 mm
(D17064 / TB CXCV 94)

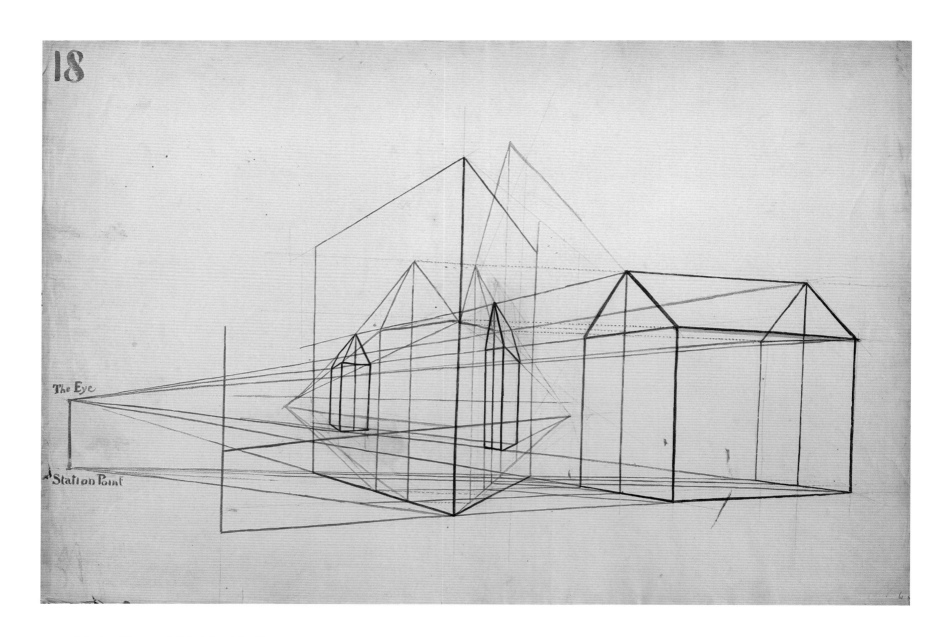

The Eye

Station Point

PLATE 8 *Lecture Diagram 18: Principles of Rectilinear
Perspective, c.*1810
pencil and watercolour on paper, 674 × 1000 mm
(D17031 / TB CXCV 61)

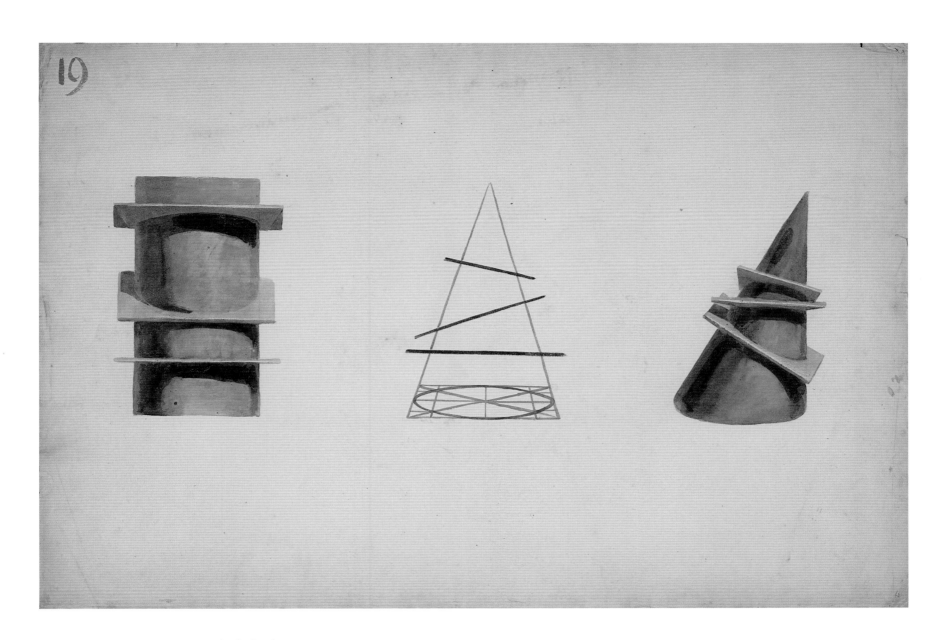

PLATE 9  *Lecture Diagram 19: Conic and Cylindrical
Sections, c.1810*
pencil and watercolour on paper, 674 × 999 mm
(D17032 / TB CXCV 62)

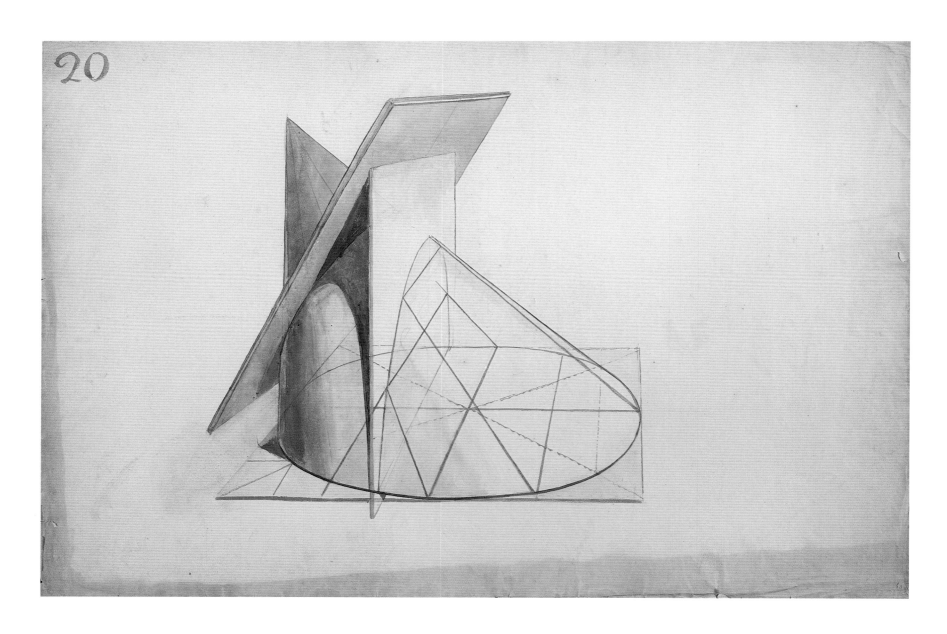

PLATE 10 *Lecture Diagram 20: Conic Sections,* c.1810
pencil and watercolour on paper, 674 × 1000 mm
(D17033 / TB CXCV 63)

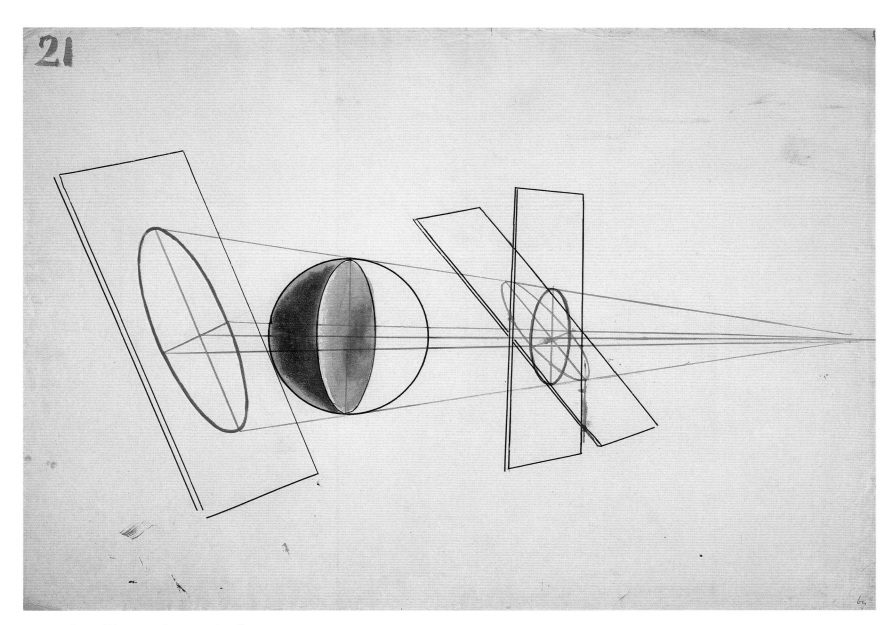

PLATE II  *Lecture Diagram 21: Representation of a*
*Globe in Perspective, c.1810*
pen and ink, watercolour on paper, 486 × 687 mm
(D17034 / TB CXCV 64)

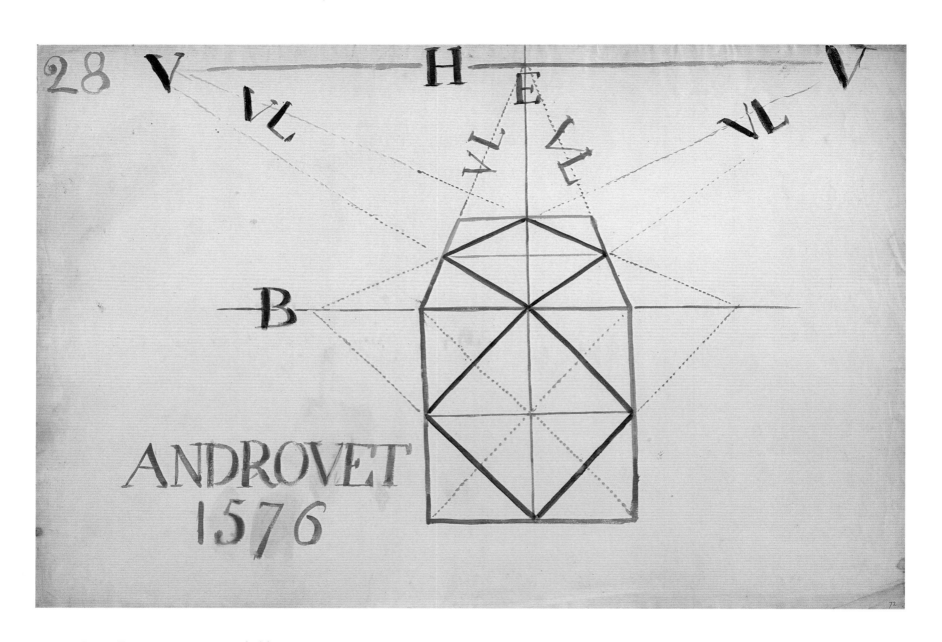

PLATE 12 *Lecture Diagram 28: Perspective Method for
a Cube by Jacques Androuet Du Cerceau, c.1810*
pencil and watercolour on paper, 672 × 999 mm
(D17042 / TB CXCV 72)

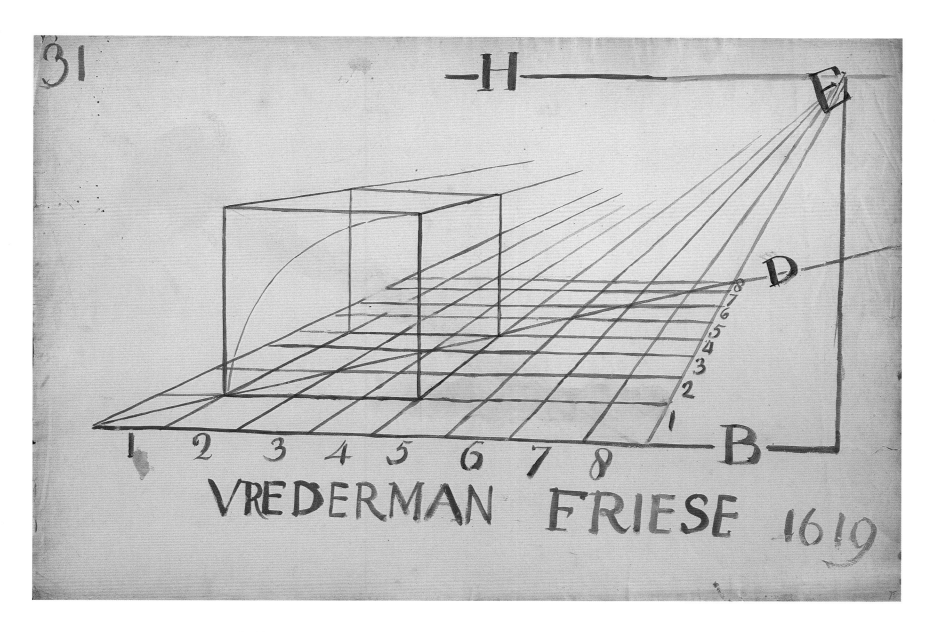

PLATE 13 *Lecture Diagram 31: Perspective Method for
a Cube by Hans Vredemans de Vries, c.1810*
pencil and watercolour on paper, 671 × 998 mm
(D17054 / TB CXCV 75)

work on the church of Il Gesù in Rome, whose *Le due regole della prospettiva practica* (1583) became the definitive statement on Renaissance perspective.

After familiarizing his students with methods for drawing squares and circles in perspective, Turner tackled the various architectural orders. He started with the Tuscan (plate 15), worked his way through elements of the Ionic and Corinthian orders (plate 16), and then concluded with a section demonstrating how to put these parts together to draw a regular building in perspective. He chose as his example Pulteney Bridge in Bath, built in the 1770s by the architect Robert Adam, because it combined both squares and circles and has both columns and entablatures in projecting colonnades. Based on an aquatint of the bridge by Thomas Malton Junior, Turner's diagrams (plates 17–18) demonstrated how to use the measure-point method in order to lay out the various elements of the building.[37] Turner concluded Lecture 4 with the hope that he had been 'fortunate amid such a maze of points as to have been sufficiently explanatory, and have thoroughly been understood in the various modes of procedure endeavoured to be explained'.[38] If this was the case, his students should have been 'in possession of such rules that are capable, by their joint accordance and power, of proving themselves equal to the difficulty of placing any building in perspective whatever as to form, size, proportion, order, or arrangement'.

Assuming his students were now well versed in the basic principles of linear perspective, he turned his attention to 'aerial' or atmospheric perspective, that 'department' of art treating light and shade, colour and reflection which he called 'the end, the mead of all our toil'.[39] And although he admitted that the rules were again inadequate, he explained that 'the road is open to practice and observation'. In Lecture 5, which addressed the nature of reflection and refraction, he provided a series of diagrams of globes, some made of polished metal (plate 19), others transparent and half-filled with water. With these delicately drawn watercolours Turner relied upon his own observations to show how light cast from windows reflects on such round shapes. As a result, the viewer is treated to a glimpse of the artist's studio, with its three large sash-windows and a nearby fireside apparent in the reflections.

Turner concluded the series with a general lecture on landscape painting, presumably in order to incorporate his own interests into the course material.[40] This has led some to suggest that he would have preferred being a professor of landscape, a position he noted to the engraver John Landseer in 1811 as worth creating at the Academy. The perspective course may be seen as 'a trial run for one on landscape, the subject that really engrossed him'.[41] Yet he seems to have continually adapted and revised his lectures on perspective in order to reflect his developing interests. Over the years he added

24

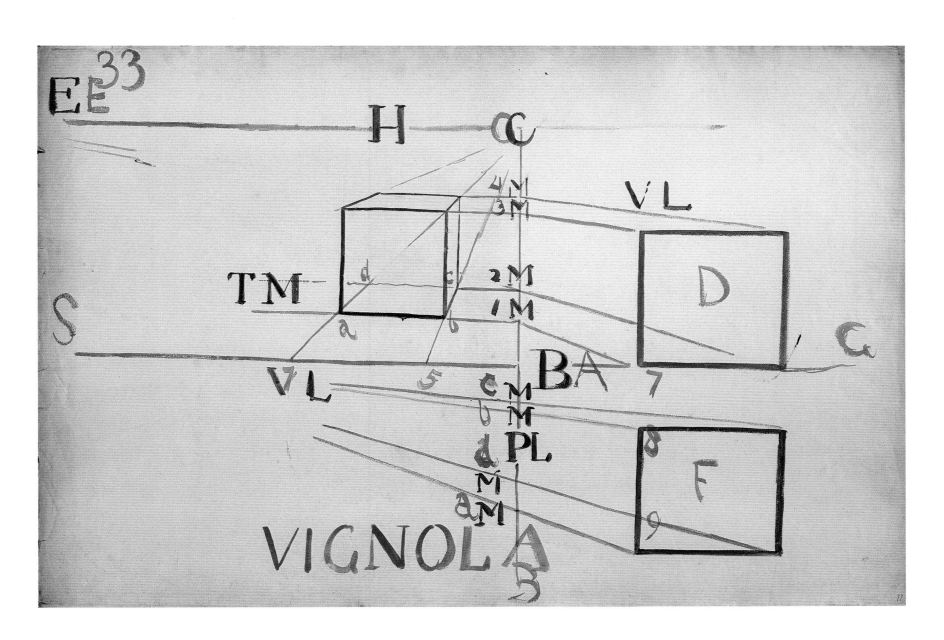

PLATE 14 *Lecture Diagram 33: Perspective Method for*
*a Cube by Jacopo Vignola, c.1810*
pencil and watercolour on paper, 672 × 1004 mm
(D17047 / TB CXCV 77)

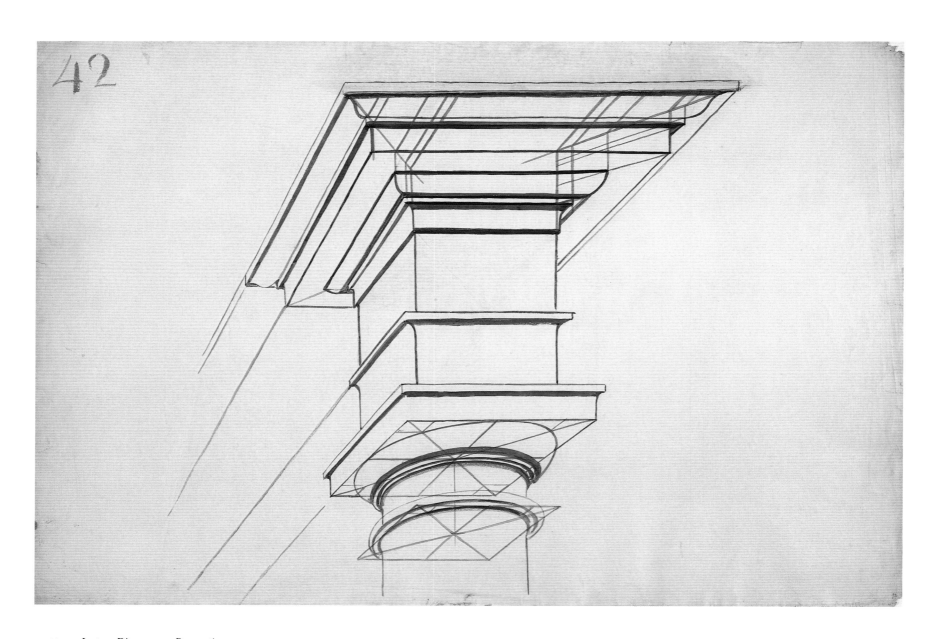

42

PLATE 15 *Lecture Diagram 42: Perspective*
*Construction of a Tuscan Entablature, c.1810*
pencil and watercolour on paper, 672 × 1004 mm
(D17062 / TB CXCV 92)

26

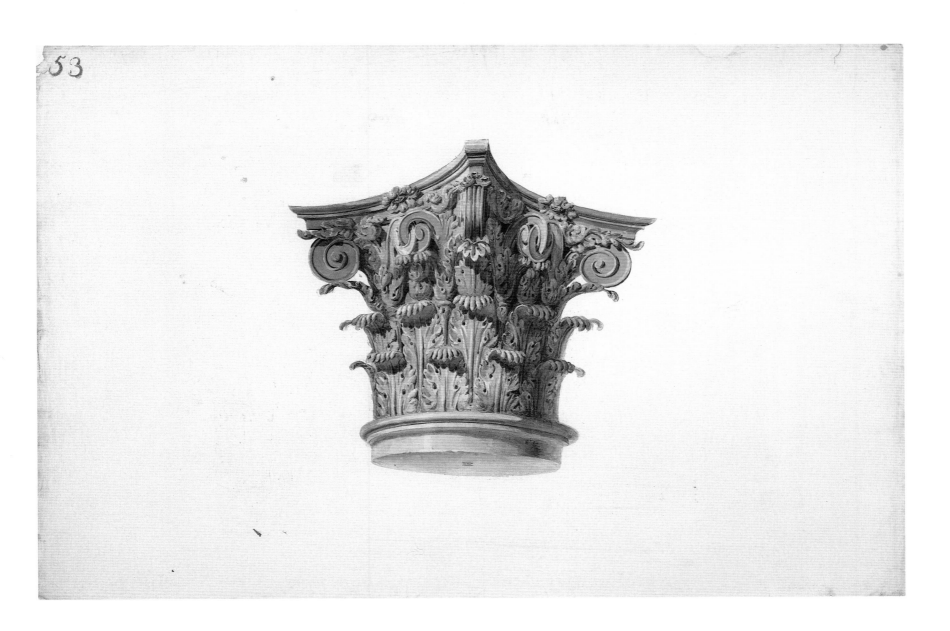

PLATE 16 *Lecture Diagram 53: Corinthian Capital in Perspective, c.*1810
watercolour over transfer ink on paper, 674 × 1010 mm
(D17073 / TB CXCV 103)

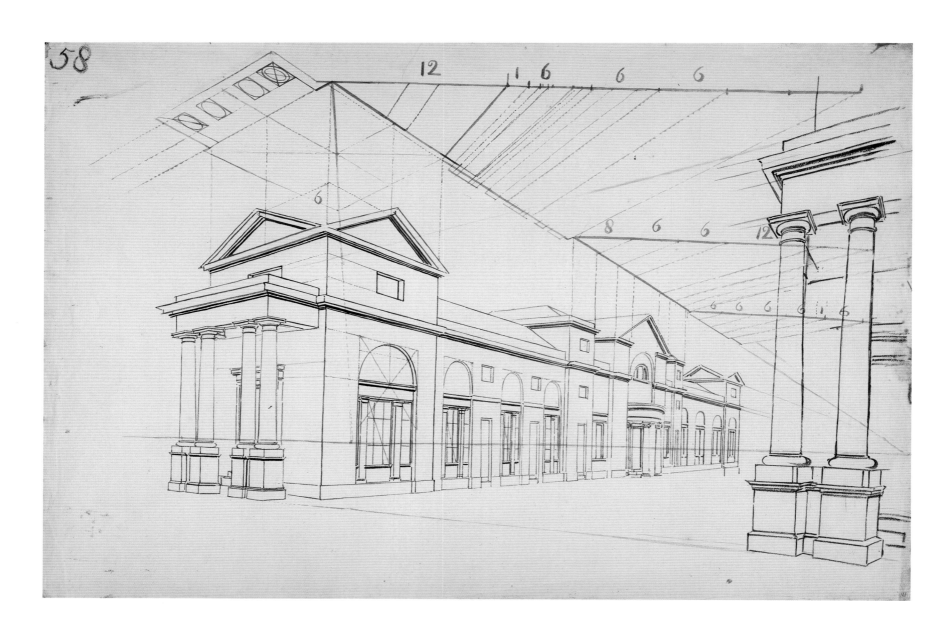

PLATE 17 *Lecture Diagram 58: Perspective Construction of Pulteney Bridge, Bath, c.1810*
pencil and watercolour on paper, 674 × 1006 mm
(D17083 / TB CXCV 113)

28

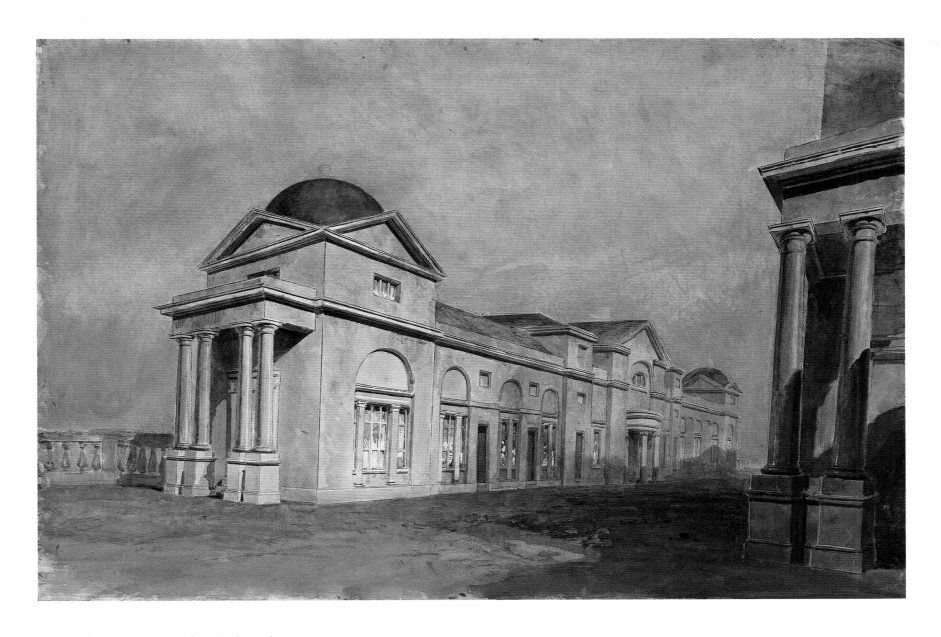

PLATE 18 *Lecture Diagram 59: Pulteney Bridge, Bath,*
*in Perspective, c.*1810
watercolour over transfer ink on paper, 672 × 999 mm
(D17084 / TB CXCV 114)

batches of visual material to supplement his portfolio. Some time after 1817 he produced a number of diagrams illustrating propositions from Euclid's *Elements of Geometry*, a handful reproducing methods for drawing a cube in an attempt to update his history of techniques, and also a few after John Joshua Kirby's theory of optics. Towards the end of his tenure, in the mid-1820s, he added two diagrams (frontispiece and plate 20) to complement passages on colour theory that he had inserted into his lectures. The diagrams are based on the colour wheels of Moses Harris, who, in his *Natural System of Colours* (*c*.1770) had illustrated his theory by depicting overlapping triangles of primary colours surrounded by a circle of their mixtures. Turner may have become interested in the material when coming across the Academy's new Professor of Painting, Thomas Phillips, preparing for his own lectures.[42] While Phillips embraced Harris's ideas on the subject, particularly his emphasis upon prismatic harmony, Turner rethought and then reconfigured the colour circle in order to explore in a more nuanced fashion the role of light and pigment mixtures in what he called 'aerial' and 'material' colours.[43] Again, even at this late stage in his teaching career, we see him consulting and then referring to tried and tested elements of perspective theory, but with a creative licence that enabled him to test their potential for artistic practice.

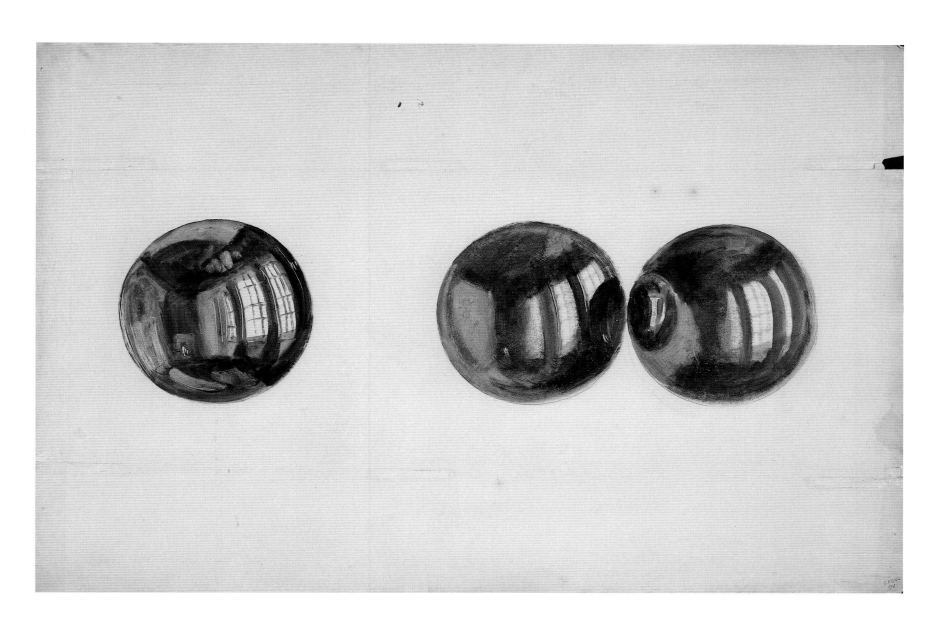

PLATE 19 *Reflections in a Single Polished Metal Globe*
*and in a Pair of Polished Metal Globes, c.*1810
oil and pencil on paper, 640 × 968 mm
(D17147 / TB CXCV 176)

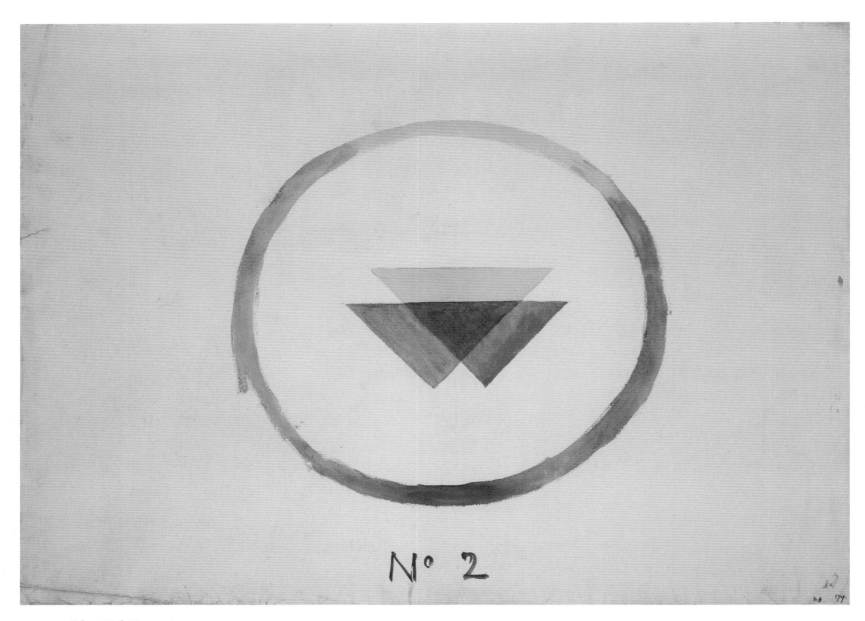

PLATE 20  *Colour Circle No.2, c.1824–8*
pencil and watercolour on paper, 550 × 758 mm
(D17150 / TB CXCV 179)

## PERSPECTIVE IN PRACTICE

Turner argued again and again that it was crucial to know the rules of perspective in order to see how far they could be valuable, thereby creating 'a confidence unattainable by any other method which cojointly enables the mind not only to act for itself but to appreciate with truth and force what nature's laws declare'.[44] While this may be evident to the patient reader of his manuscripts, the professor himself failed to convey this to his students. One commentator in 1819, for instance, made the particularly strong statement that Turner:

> delivered his usual course to the students, distinguished for its usual inanity, want of connection, bad delivery and beautiful drawing. It is painful to speak thus of a man of such talent as Turner; but it is clear, that he is either incompetent to teach this elementary branch of fine arts, which is, like thorough bass to music, the piles and planking of the foundation on which the solidity of the superstructure depends, or, he withholds his knowledge from the students.[45]

In response he tried different ways to address these failings and, at some point, even went through his lecture texts to add eye-catching red commas to alert himself to natural pauses.[46] But students continued to drop from the course, perhaps drawn instead to the lively stagings given by Anthony Carlisle, the Professor of Anatomy, who once gave a lecture using semi-nude Life Guardsmen to illustrate how muscles were used in swordplay; it caused such a crowd that police had to disperse the meeting.[47] Increasingly Turner failed to deliver entire courses. He stopped completely after 1828, but only sent in his resignation in December 1837, presumably after a Select Committee on Arts and Manufactures had met to discuss the future of the Royal Academy, and its President, Sir Martin Archer Shee, had been forced to address his institution's failure to press the Professor of Perspective into executing his duties.[48]

The focus upon Turner's poor delivery has done much to overshadow the true force of the lecture material – his ardent belief that an understanding of perspective was crucial to the practice of any artist, whether architect, draughtsman, sculptor or painter. This is particularly obvious in Lecture 1, where his aim was to draw his students into the subject, something he accomplished via a number of beautifully rendered watercolours. Here he showed, for instance, how basic geometry informed the compositions of the Old Masters (plate 21). He also demonstrated how the Romans took into account the situation of viewers at ground level when giving figures on columns high above them their due

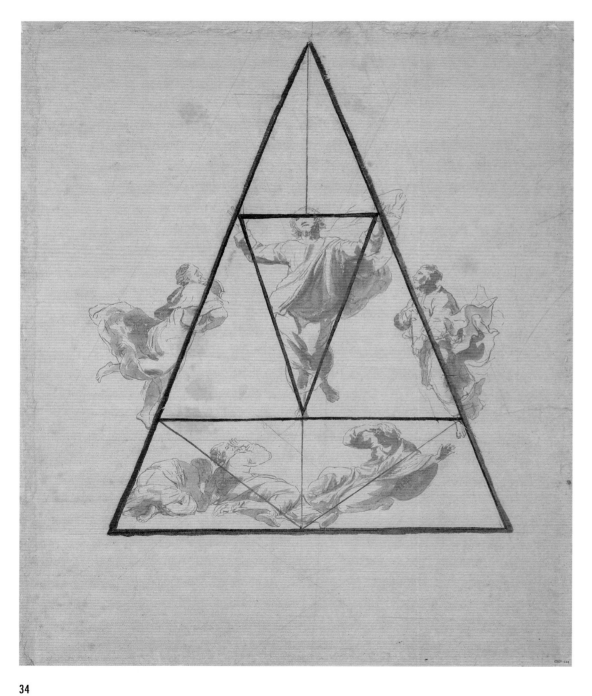

PLATE 21  *Lecture Diagram 10: Proportion and
Design of Raphael's 'Transfiguration', c.*1810
pencil and watercolour on paper, 617 × 507 mm
(D17134 / TB CXCV 163)

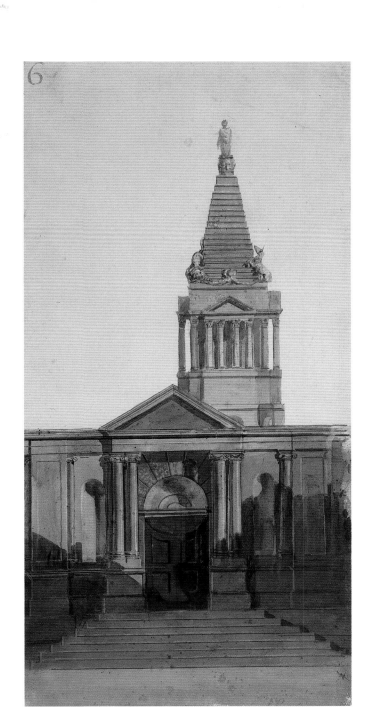

PLATE 22 *Lecture Diagram 6: St. George's Church,*
*Bloomsbury, c.1810*
pencil and watercolour over transfer ink on paper, 708 × 348 mm
(D17115 / TB CXCV 144)

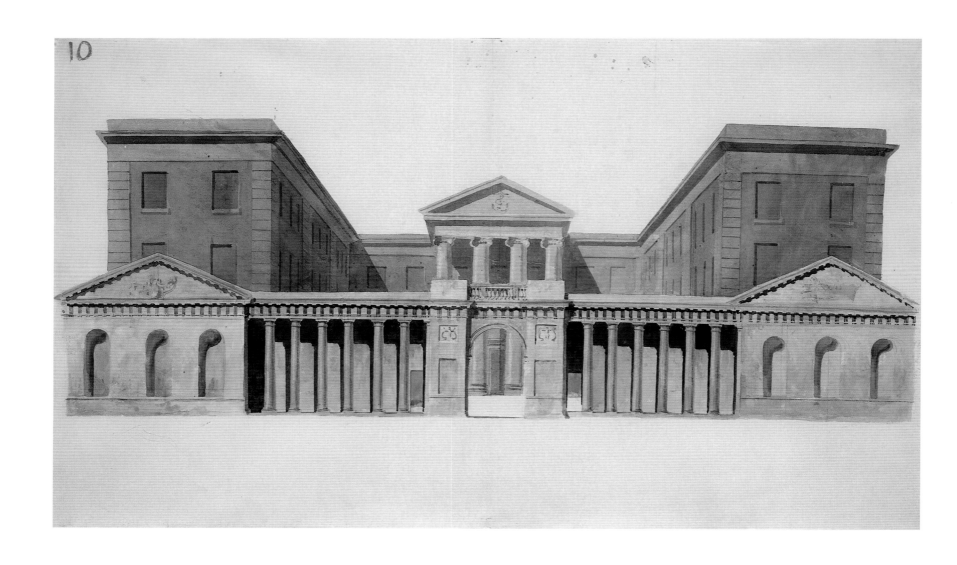

PLATE 23 *Lecture Diagram 10: The Admiralty, c.*1810
pencil and watercolour on paper, 782 × 1328 mm
(D17144 / TB CXCV 173)

proportion. Turner pushed his students to do the same in their own practice. He brought in a frontal elevation of St George's Church in Bloomsbury (plate 22), built by Nicholas Hawksmoor, *c.*1720–30, to show how the stepped tower had been designed to accommodate and help lift the sculpture of George II at its apex so that it could be seen at street level. But he also put before them a number of elevations (plate 23) that were purposely unsatisfactory in their treatment of perspective in order to demonstrate precisely why a knowledge of rules was so important, as well as how far one could bend them to achieve certain results.

Turner had special use for standard perspective in his ambitious exhibition pictures that encompassed grand historical themes. Here perspective served as a technical and expressive device for bridging not only foreground and background, but also past and present. In *The Decline of the Carthaginian Empire* (plate 24), exhibited in 1817, for instance, he clearly established an illusion of receding space upon the flat surface of his canvas. He presented the viewer with a series of levels or grounds that receded to a horizon point, with the contours of the landscape and architecture helping to guide the eyes into the distance, towards the setting sun. The gradation of colour and careful shading enhanced this sense of depth, but also gave the scene a warm glow that evoked the landscapes of the seventeenth-century painter Claude, whom Turner sought to emulate. Yet Turner also employed perspective in more unconventional ways in order to engage his viewer on an emotional level. It quickly becomes apparent, for example, that many of the lines do not converge towards the horizon but veer off towards disparate areas of the panorama or curve in unsettling ways to give an overall impression of instability or 'slackness'.[49] Such curvilinear, often collapsing forms contributed to the themes of languor and decline he sought to highlight in this epic picture recounting the fall of the maritime empire of Carthage.[50] Ultimately Turner manipulated perspective in order to elevate and make more complex the narrative possibilities of the historical scene. As demonstrated in the lectures, he was interested in perspective primarily as a means to an end, not only as a visual device enabling the artist to achieve particular effects, but also as a language with which to expand upon experience.

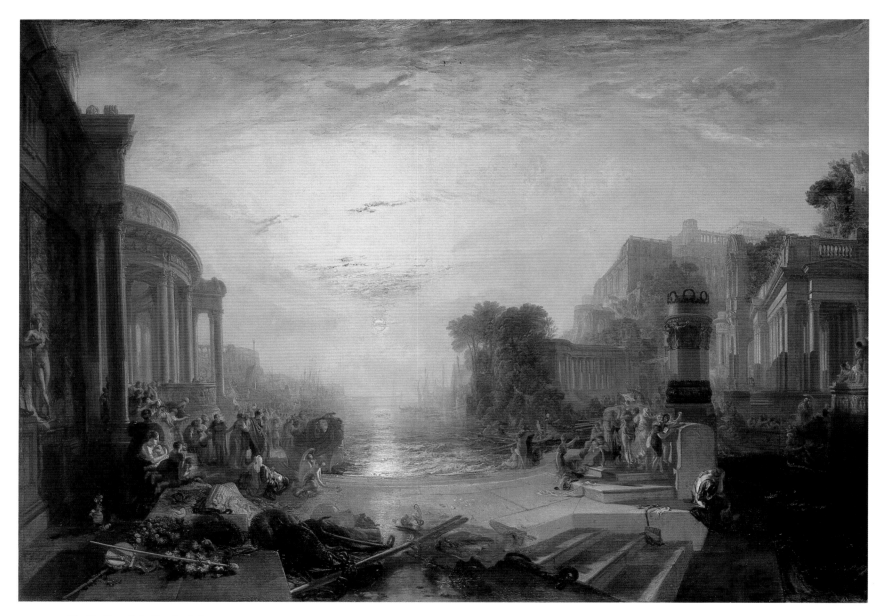

PLATE 24  *The Decline of the Carthaginian Empire*, exhibited 1817

oil on canvas, 1702 × 2388 mm

(N00499)

# NOTES

This publication stems from research completed while I was a Samuel H. Kress Fellow in the Collections Division at Tate Britain. Thanks are extended to David Blayney Brown, Maurice Davies, Christine Riding and Andrew Wilton for their advice and encouragement. I would also like to thank Nicola Cole, Juliet Cook and Sarah Taft for all their practical assistance. My deepest gratitude goes to Justin and Clio.

1   W.T. Whitley, 'Turner as Lecturer', *The Burlington Magazine*, vol.22, 1913, pp.205–7.
2   J.M.W. Turner, 'Royal Academy Lectures', c.1807–38, Department of Western Manuscripts, British Library, London, Add. MS 46151 BB f.53v.
3   *Morning Chronicle*, 5 January 1814.
4   *New Monthly Magazine*, 1 February 1816.
5   Richard and Samuel Redgrave, *A Century of Painters of the English School*, London 1866, p.95.
6   Maurice Davies, *Turner as Professor: The Artist and Linear Perspective*, exh. cat. Tate Gallery, London 1992, p.23; John Ruskin, *The Works of John Ruskin*, Library Edition, ed. E.T. Cook and A. Wedderburn, 1903–12, vol.7, p.446.
7   I would like to thank Joyce Townsend and Piers Townshend for providing me with this information on Turner's copying methods.
8   The later diagrams do not have this numbering system.
9   Peter Bower, *Turner's Papers: A Study of the Manufacture, Selection and Use of his Drawing Papers, 1787–1820*, exh. cat. Tate Gallery, London 1990, pp.110–11.
10  A.J. Finberg, *A Complete Inventory of the Drawings of the Turner Bequest*, vol.1, 1909, p.v.
11  There are twenty-eight manuscripts in the Department of Western Manuscripts at the British Library (Add. MS 46151 A–Z, AA, BB). Three remain in a private collection.
12  Jerrold Ziff, '"Backgrounds, Introduction of Architecture and Landscape": A Lecture by J.M.W. Turner', *Journal of the Warburg and Courtauld Institutes*, vol.26, 1963, pp.124–47; for passages on colour theory, see John Gage, *Colour in Turner: Poetry and Truth*, London 1969, pp.196–214.
13  The most comprehensive studies of the diagrams remain Davies 1992 and Maurice Davies, 'J.M.W. Turner's Approach to Perspective in his Royal Academy Lectures of 1811', unpublished Ph.D. thesis, Courtauld Institute of Art, London 1994. I thank Davies for giving me access to his unpublished notes and transcriptions of Turner's lectures.
14  *Abstract of the Constitution and Laws of the Royal Academy of Arts in London*, London 1815, pp.18–19.
15  BL, MS K f.2r.
16  Ziff 1963, p.126.
17  William Sandby, *The History of the Royal Academy of Arts*, London 1862 and Sidney C. Hutchison, *The History of the Royal Academy*, London 1968.
18  Davies 1992 and 1994.
19  The sketchbooks are now housed at Tate Britain.
20  Davies 1992, p.19.
21  Martin Kemp, *The Science of Art: Optical Themes in Western Art from Brunelleschi to Seurat*, New Haven and London 1990, p.301.
22  I would like to thank Mark Pomeroy, Archivist at the Royal Academy, for much of this information. See also, Sandby 1862; Hutchinson 1968.
23  Royal Academy Council Minutes, 15 December 1809.
24  Hutchison 1968, pp.88–9.
25  Redgrave 1866, p.95.
26  Davies 1992, p.26.
27  BL, MS L f.2v.
28  Malton 1778 edn, p.12, plate 1, figure 3.
29  Davies 1992, p.37.
30  BL, MS L f.3r.
31  BL, MS L ff.4r–6v; M ff.8v, 32r.
32  Davies 1994, p.293 n.6; Wilton 1987, p.21.
33  BL, MS L f.6v.
34  Davies 1994, pp.51–2.
35  BL, MS L f.17r.
36  Kemp 1990, pp.109–11.
37  Turner may in fact have traced Malton's aquatint.
38  BL, MS M f.21v–22r.
39  BL, MS M f.23r.
40  This lecture, which Turner titled 'Backgrounds, Introduction of Architecture and Landscape', has been edited and published in Ziff 1963.
41  Wilton 1987, p.102.
42  Gage 1969, p.116.
43  Kemp 1990, p.301.
44  BL, MS L f.17r.
45  Anonymous, *Annals of Fine Arts*, vol.iv, London 1820, p.98.
46  Davies 1992, p.27; Brian Butterworth, 'Was Turner Dyslexic?', *Turner Studies*, vol.11, no.1, 1991, pp.5–6.
47  Hutchison 1968, p.98.
48  Royal Academy Council Minutes, 28 December 1837. For parliamentary inquiry, see Hutchison 1968, pp.105–7; Gage 1987, pp.144–5; Davies 1992, p.28
49  Eric Shanes, *Turner's Human Landscapes*, London 1990, p.200.
50  Kathleen Nicholson, *Turner's Classical Landscapes: Myth and Meaning*, Princeton 1990, p.105.